CHRISTOPHER HART'S
DRAW MANGA NOW!

Anatomy 101

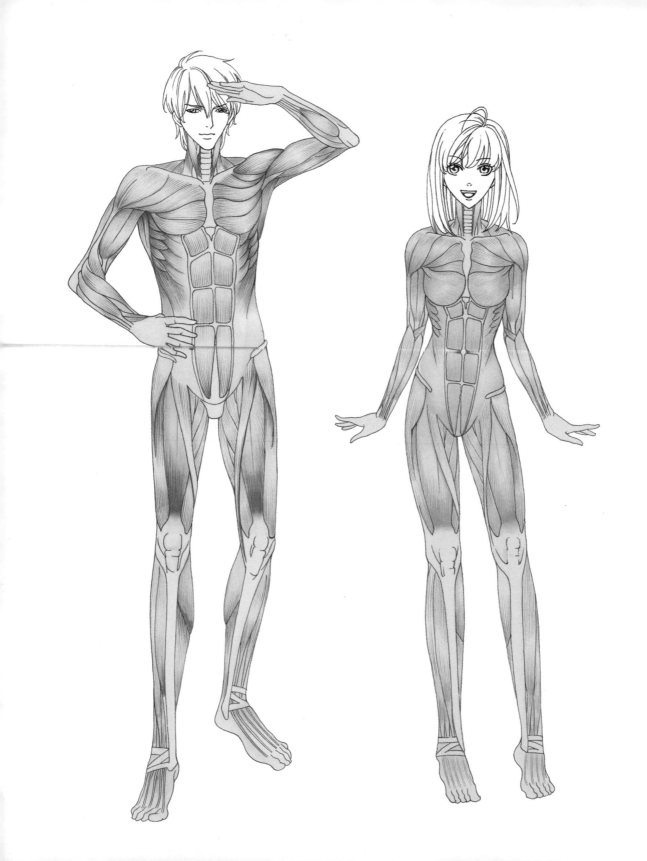

CHRISTOPHER HART'S DRAW MANGA NOW!

Anatomy 101

Christopher Hart

Watson-Guptill Publications
New York

Published in the United States by Watson-Guptill Publications, an imprint
of the Crown Publishing Group, a division of
Random House, Inc., New York.

www.crownpublishing.com
www.watsonguptill.com

WATSON-GUPTILL is a registered trademark and the WG and Horse
designs are trademarks of Random House, Inc.

This work is based on the following titles by Christopher Hart published
by Watson-Guptill Publications, an imprint of the Crown Publishing Group,
a division of Random House, Inc.: *Manga for the Beginner*, copyright
© 2008 by Christopher Hart; *Manga for the Beginner Shoujo*, copyright
© 2010 by Cartoon Craft LLC; and *Basic Anatomy for the Manga Artist*,
copyright © 2011 by Art Studio LLC.

Library of Congress Cataloging-in-Publication Data
Hart, Christopher, 1957-
Christopher Hart's draw manga now! : anatomy 101 /
Christopher Hart.—1st ed.
p. cm.
1.Comic books, strips, etc.—Japan—Technique. 2. Cartoon characters—
Japan. 3. Figure drawing—Technique. 4. ART/Techniques/Drawing. 5.
ART/Study & Teaching. 6. ART/Techniques / General.
NC1764.5.J3 H36916 2013 741.5/1

ISBN 978-0-385-34587-3
eISBN 978-0-385-34588-0

Cover and book design by Ken Crossland
Printed in the United States of America

10 9 8 7 6 5 4 3 2 1
First Edition

Contents

Introduction

The ability to represent the human head and figure is essential for drawing manga. However, it can be trickier than it seems. Here's a source you can turn to for the answers you've been seeking.

And unlike so many books on anatomy, this one won't intimidate you. All of the information is presented in a clear, useful, and practical way.

So if you want to improve your manga and don't know where to begin, this is a great place to start. If you're a beginner, this book can help you build a solid foundation. It's a must-have reference that will serve you throughout your adventures as a manga artist.

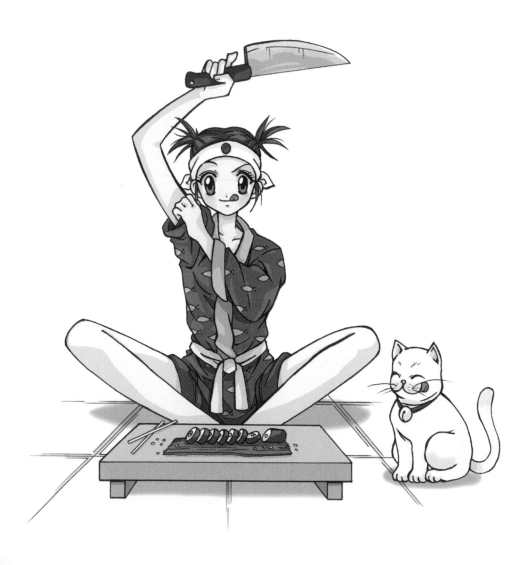

To the Reader

This book may look small, but it's jam-packed with information, artwork, and instruction to help you learn how to draw manga like a master!

We'll start off by going over some of the basic elements of manga anatomy. Pay close attention; the material we cover here is very important; everything builds on these basics. You might want to practice drawing some of the things in this section before moving on to the next one.

Then, it'll be time to pick up your pencil and get drawing! You'll follow my step-by-step illustrations on a separate piece of paper, drawing the characters in this section using everything you've learned so far.

Finally, I'll put you to the test! This last section features images that are missing some key features. It'll be your job to finish these drawings, giving the characters the elements they need.

This book is all about learning, practicing, and, most important, having fun. Don't be afraid to make mistakes. If you don't make any mistakes, that means you're not attempting to tackle new techniques. In fact, the more mistakes you make, the more you're learning. Also, the examples are meant to be guides; feel free to elaborate and embellish as you wish. Before you know it, you'll be a manga artist in your own right!

Let's begin!

PART ONE
Let's Learn It

The Head

We'll start by building a foundation so that your manga characters look like, well, manga characters! Why settle for so-so drawing when just a few basic concepts can transform your work beyond your expectations? Time to get your pencils out!

Let's begin with a review of the head. If you're going to raise your skill level in one area (drawing the body), it makes sense to also raise your skill level in a related area (drawing the head) so that your abilities don't become lopsided.

So we'll start off with a look at the skull. You see that the cheekbones provide the width of the face, and the size of the forehead relative to the chin is huge.

The skull here answers many common questions about why the head looks the way it does. Why do manga characters have such big eyes? Just look at how large the eye sockets are. Also notice the extraordinary width of the cheekbones. And manga characters also typically have small chins, as is reflective of the skull structure. All these things contribute to cuteness.

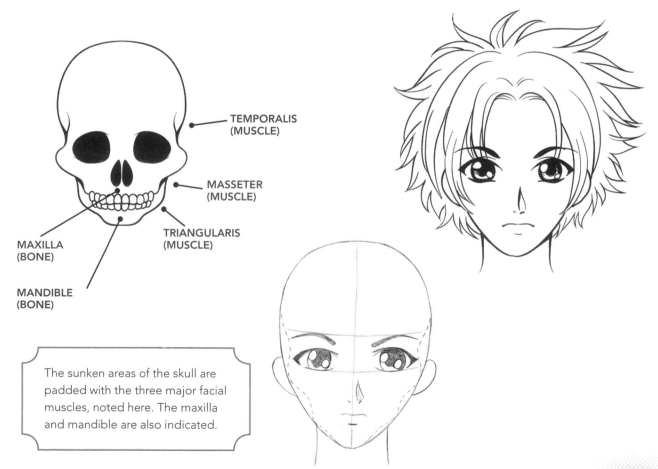

TEMPORALIS
(MUSCLE)

MASSETER
(MUSCLE)

TRIANGULARIS
(MUSCLE)

MAXILLA
(BONE)

MANDIBLE
(BONE)

The sunken areas of the skull are padded with the three major facial muscles, noted here. The maxilla and mandible are also indicated.

Front-View Structure Specifics

Now that you've got an idea of the shape of the underlying skull, you're ready for the head's key anatomical aspects. The crossed lines help keep the features aligned. Draw them lightly, and erase them once you've finished the face. The center line divides the head in half. The eye line falls where the jaw and skull meet and helps artists keep the eyes even, so that one doesn't appear higher or lower than the other. The mouth guideline falls at the bottom of the skull circle, about halfway between the eye line and the bottom of the chin. The chin is pointed. The distance between the eyes is approximately one eye width. And the eyes are huge and low on the face (the bottom eyelid falls on the eye line).

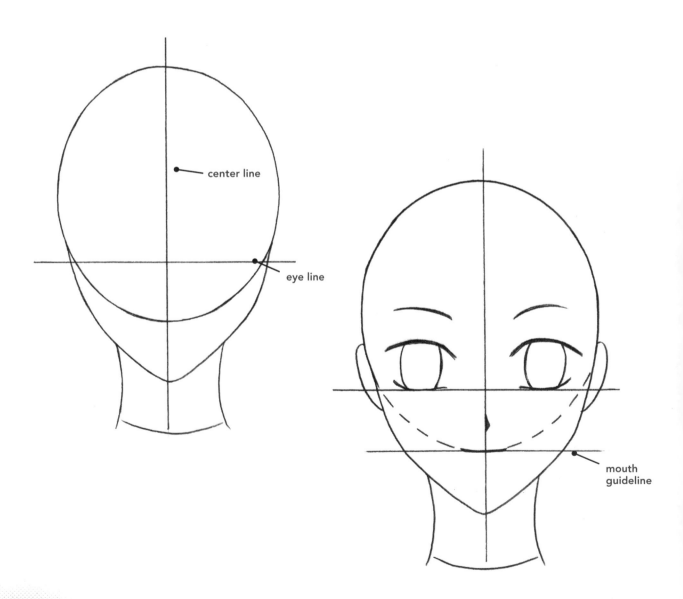

center line

eye line

mouth guideline

A Note About the Nose
Only a small, triangular shadow is needed to indicate the nose in the front view. This goes for both girls' and boys' noses.

Profile Pointers

The profile, or side view, is easy to draw—except for one part (isn't there always a "but"?). The sticking point is the mouth/chin area underneath the nose. If an artist is going to get a bit off track, that's often where it happens. Remember that the lips always protrude past the chin.

Although many people draw it to look flat, the back of the head is round. The same holds true for the top of the head. Conversely, the front of the face is fairly flat.

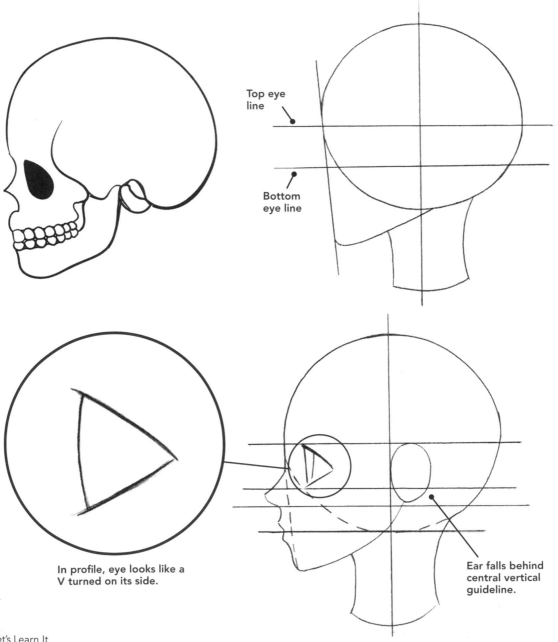

Top eye line

Bottom eye line

In profile, eye looks like a V turned on its side.

Ear falls behind central vertical guideline.

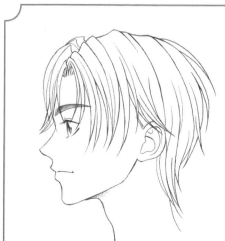

The Male Profile

This is mostly similar to the female profile, but note one important difference: the jawline is hard, not soft.

Understanding the Skeleton

There are five major reasons a working familiarity with the skeleton is a benefit for manga artists: (1) The skeleton is the framework of the body and provides it with its basic angularity and shape. (2) Many of the bones "show through" the skin surface, so you have to know where they go. (3) The various thicknesses of the bones determine the thicknesses of the body parts and limbs. (4) The proportions of the body can be measured or estimated by the length of the various bone segments. (5) The basic sections of the body are determined by the skeleton; examples of this are the hips (pelvis) and torso (rib cage).

Note that while there are slight differences between the male and female skeleton (for example, the female pelvis is wider), the basic components are the same, so we'll just use the male skeleton here to call out the main elements.

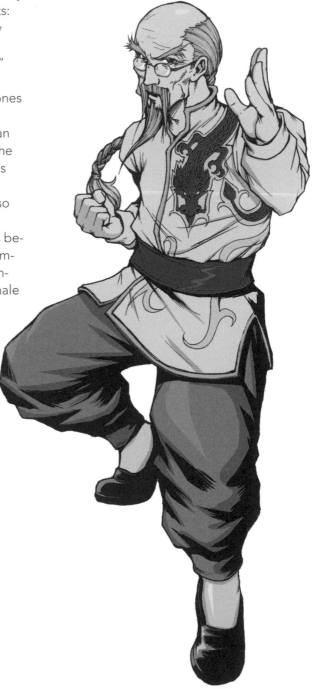

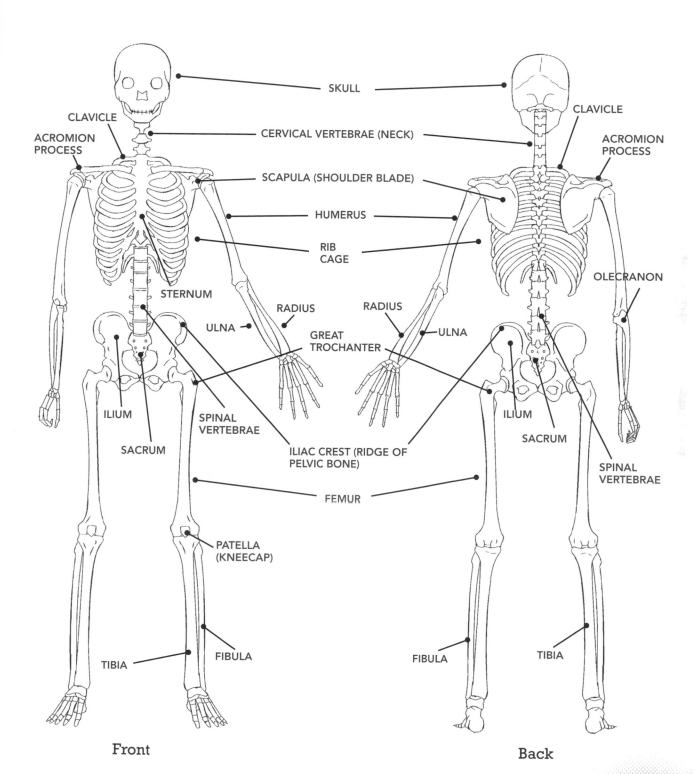

SKULL

CLAVICLE

ACROMION PROCESS

CERVICAL VERTEBRAE (NECK)

SCAPULA (SHOULDER BLADE)

HUMERUS

RIB CAGE

STERNUM

RADIUS

ULNA

GREAT TROCHANTER

ILIUM

SPINAL VERTEBRAE

SACRUM

ILIAC CREST (RIDGE OF PELVIC BONE)

FEMUR

PATELLA (KNEECAP)

TIBIA

FIBULA

CLAVICLE

ACROMION PROCESS

OLECRANON

RADIUS

ULNA

ILIUM

SACRUM

SPINAL VERTEBRAE

FIBULA

TIBIA

Front

Back

Simplified Skeleton

Now that you've examined the skeleton, you can begin to use it as the foundation for your drawings. Since it would be too time-consuming to use the detailed skeleton, opt instead for a simplified version, like what you see here. The simplified skeleton serves as an excellent model, especially when deconstructing difficult poses. When you come across a pose that's challenging, you can first plot out the figure as a simplified skeleton and then fill in the body's outline around it.

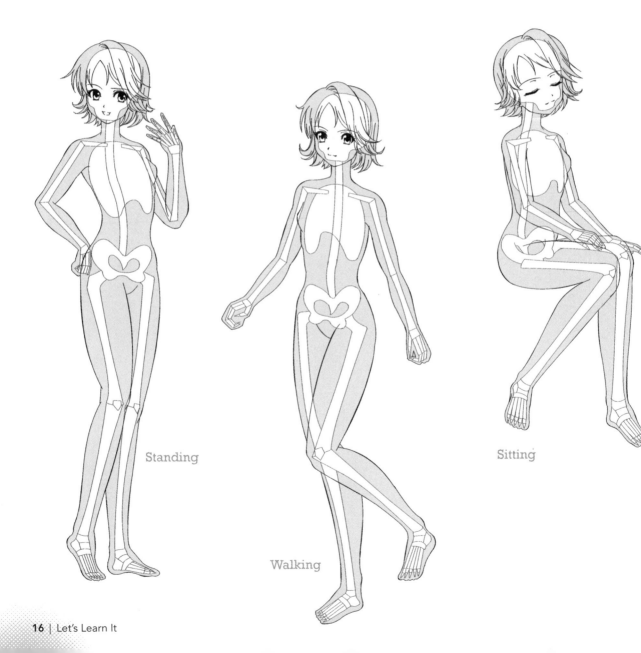

Standing

Walking

Sitting

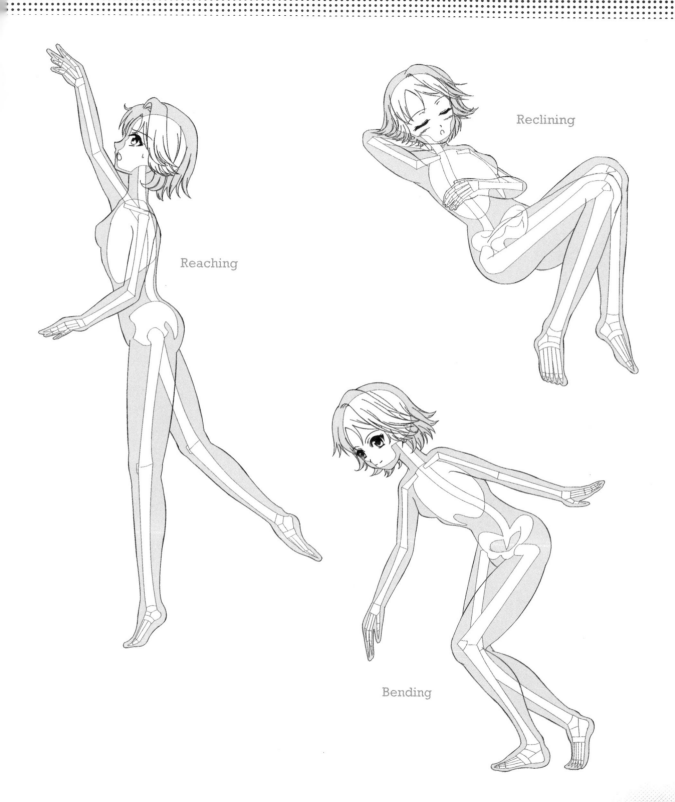

Reaching

Reclining

Bending

Understanding the Muscles

Simply observing the various muscle groups, their basic shapes, and the way they lead into one another will improve your knowledge—and that's even before you pick up a pencil.

Memorization isn't necessary—if there's something you need to know, just pull out this book and refresh your memory.

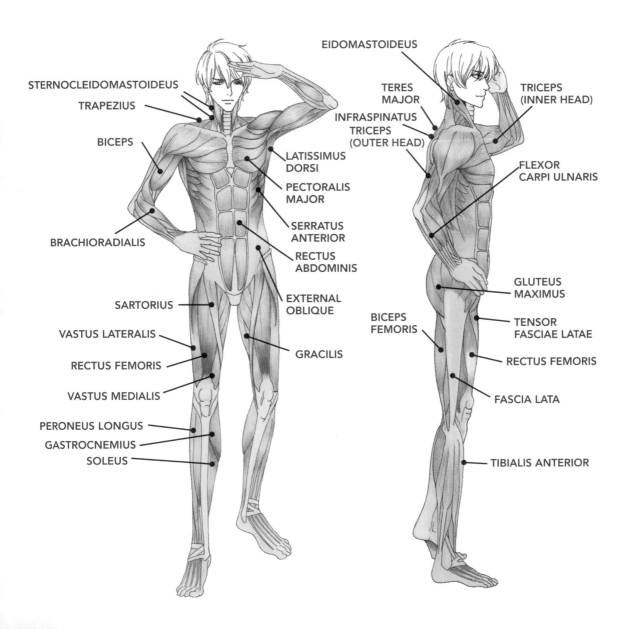

STERNOCLEIDOMASTOIDEUS

TRAPEZIUS

BICEPS

BRACHIORADIALIS

SARTORIUS

VASTUS LATERALIS

RECTUS FEMORIS

VASTUS MEDIALIS

PERONEUS LONGUS

GASTROCNEMIUS

SOLEUS

EIDOMASTOIDEUS

LATISSIMUS DORSI

PECTORALIS MAJOR

SERRATUS ANTERIOR

RECTUS ABDOMINIS

EXTERNAL OBLIQUE

GRACILIS

TERES MAJOR

INFRASPINATUS

TRICEPS (OUTER HEAD)

BICEPS FEMORIS

TRICEPS (INNER HEAD)

FLEXOR CARPI ULNARIS

GLUTEUS MAXIMUS

TENSOR FASCIAE LATAE

RECTUS FEMORIS

FASCIA LATA

TIBIALIS ANTERIOR

Male

Since the difference between the male and female figure really starts to take shape with the muscles, it's a good idea to cover both. We'll start with the male. Keep in mind that you won't show all these muscles in your finished drawings; having too many "definition lines" in the interior of the figure would be overkill. The muscles can usually be sufficiently defined solely by articulating their shape in the outline of the figure.

STERNOCLEIDOMASTOIDEUS

TRAPEZIUS

DELTOID

FLEXOR CARPI RADIALIS

BRACHIALIS

SCAPULA (SHOULDER BLADE)

LATISSUMUS DORSI

EXTERNAL OBLIQUE

EXTENSOR CARPI RADIALIS LONGUS

BRACHIORADIALIS

ADDUCTOR MAGNUS

VASTUS LATERALIS

BICEPS FEMORIS

SEMITENDINOSUS

GASTROCNEMIUS

PERONEUS LONGUS

ACHILLES TENDON

The Back

There are three things you'll want to watch for when drawing the back: (1) The shoulders aren't horizontal but slope down, due to the trapezius muscle, which connects the shoulders to the neck. (2) The hips have width, even on men. Some beginners have a tendency to draw them too narrow, and that negatively affects the placement of the legs. And (3), the legs, even the calves, have major muscles, and therefore should not be drawn skinny, even on slender characters.

Female

The difference between the male and female figure is a matter of reduced muscle mass and softer angles. Generally, the female upper body shows reduced muscle mass. Instead of having powerful shoulder muscles, her power comes from the hips and legs. The outline of the female torso has a visual rhythm—wide, narrow, wide—that the male torso lacks. This is commonly referred to as an hourglass shape. The legs taper, and to extend that tapered effect, the feet should be fairly petite.

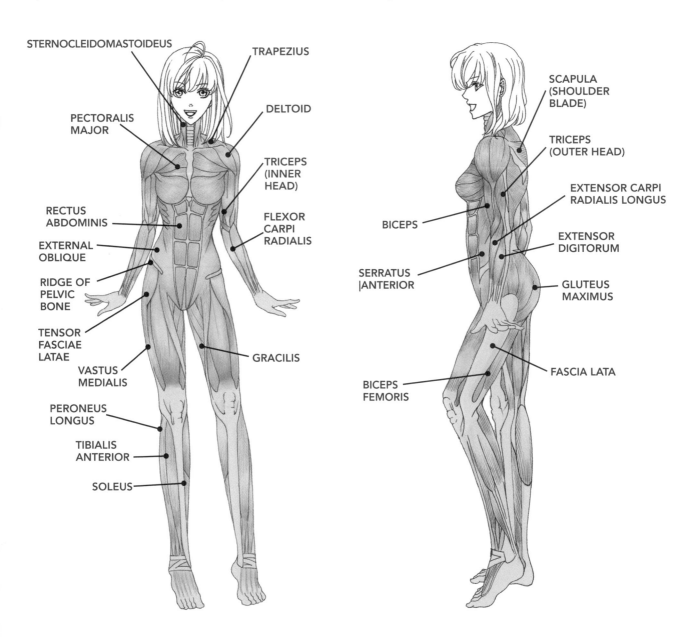

STERNOCLEIDOMASTOIDEUS

TRAPEZIUS

PECTORALIS MAJOR

DELTOID

TRICEPS (INNER HEAD)

RECTUS ABDOMINIS

FLEXOR CARPI RADIALIS

EXTERNAL OBLIQUE

RIDGE OF PELVIC BONE

TENSOR FASCIAE LATAE

VASTUS MEDIALIS

GRACILIS

PERONEUS LONGUS

TIBIALIS ANTERIOR

SOLEUS

SCAPULA (SHOULDER BLADE)

TRICEPS (OUTER HEAD)

EXTENSOR CARPI RADIALIS LONGUS

BICEPS

EXTENSOR DIGITORUM

SERRATUS |ANTERIOR

GLUTEUS MAXIMUS

FASCIA LATA

BICEPS FEMORIS

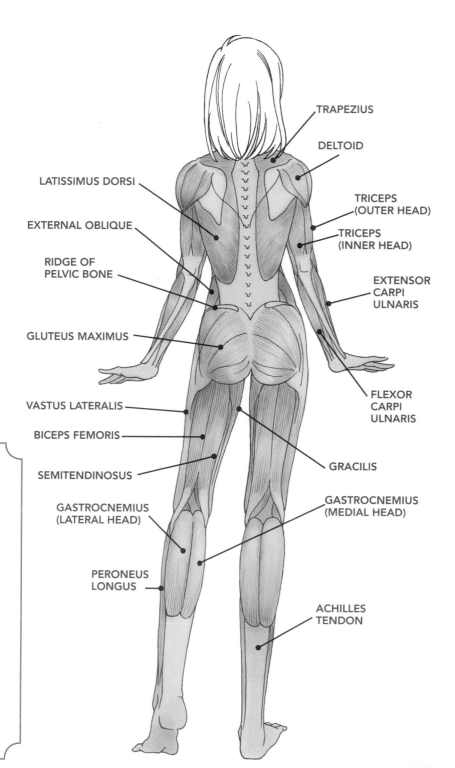

TRAPEZIUS

DELTOID

LATISSIMUS DORSI

EXTERNAL OBLIQUE

TRICEPS
(OUTER HEAD)

TRICEPS
(INNER HEAD)

RIDGE OF
PELVIC BONE

EXTENSOR
CARPI
ULNARIS

GLUTEUS MAXIMUS

FLEXOR
CARPI
ULNARIS

VASTUS LATERALIS

BICEPS FEMORIS

GRACILIS

SEMITENDINOSUS

GASTROCNEMIUS
(MEDIAL HEAD)

GASTROCNEMIUS
(LATERAL HEAD)

PERONEUS
LONGUS

ACHILLES
TENDON

The Back

It may seem counterintuitive, but women have wide backs. Of course the back width isn't the same as that of a man—but it should *not* be de-emphasized. The rear pose also provides the best view of the starting point of the waist, which occurs much higher up the torso than a man's waist. The female hips are approximately the same width as the shoulders. This is a good measurement to remember when sketching. It can help you arrive at the correct proportions.

Proportion Benchmarks

Keep the following three benchmarks in mind to help get the proportions of the figure right: (1) Men's shoulders are wider than their hips. (2) Women's shoulders and hips are the same width. (3) The elbow joint lines up with the bottom of the rib cage on both sexes.

Front View

Here are some other details to remember: A man's shoulders should look like a flexed muscle, but a woman's shoulders should not; a woman's waist falls higher up on her body than a man's falls on his; and a man's hips are taller but narrower than a woman's hips, which are shorter and wider. Take a look at the comparison drawings here.

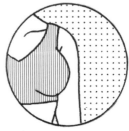
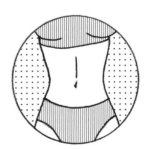

Male · Female

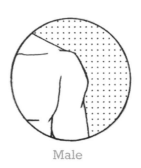
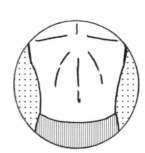

Male · Female

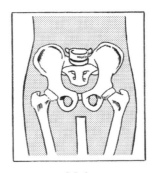
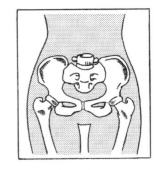

Male · Female

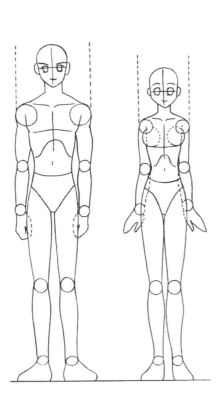

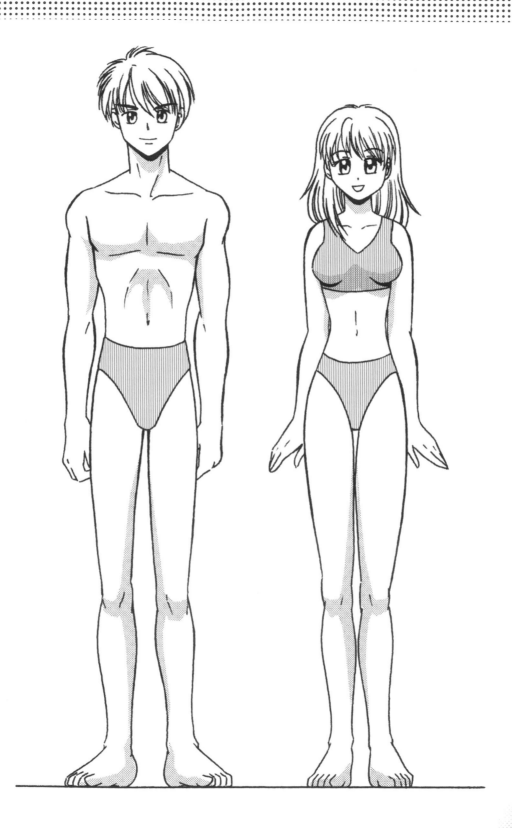

Profile

Points to note about the profile view are: The collarbone provides a small "ledge" for the chest muscles; the line of the back isn't straight but curves outward as it travels down from the neck; the torso is flatter than the back, and the curve of the lower back is more graceful and less abrupt on a woman than on a man; men's arms are more muscular and rounded out, while women's arms are sleeker and straighter; and the calves aren't skinny pipes but have some thickness.

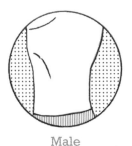

Male

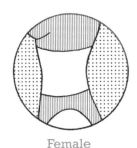

Female

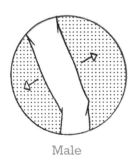

Male

Female

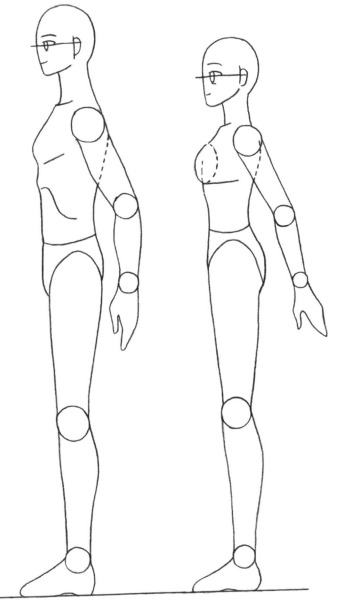

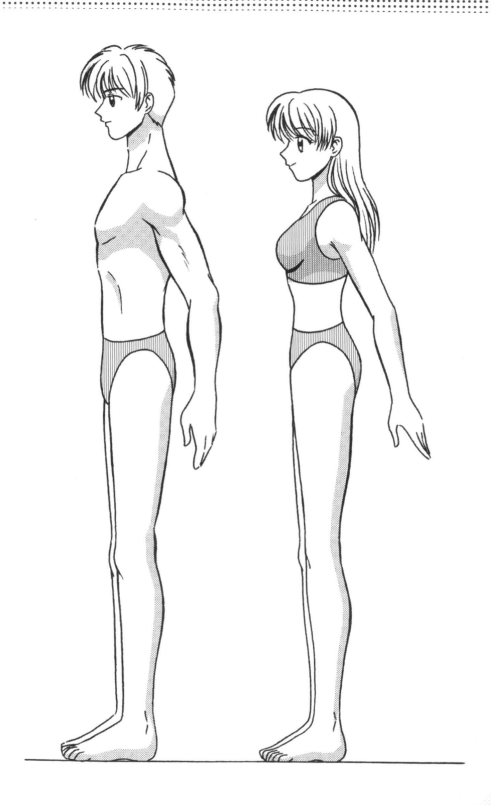

3/4 View

The 3/4 view is a very common pose. Here are a few things to note about the anatomy in this pose: The far shoulder should appear smaller than the near one, and part of it peeks out past the chest at this angle. The center of the body lines up with the center guideline on the head, which does not fall in the center of the form in the 3/4 view.

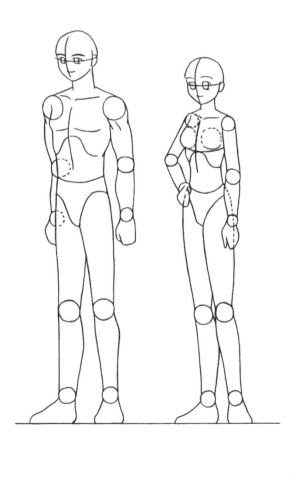

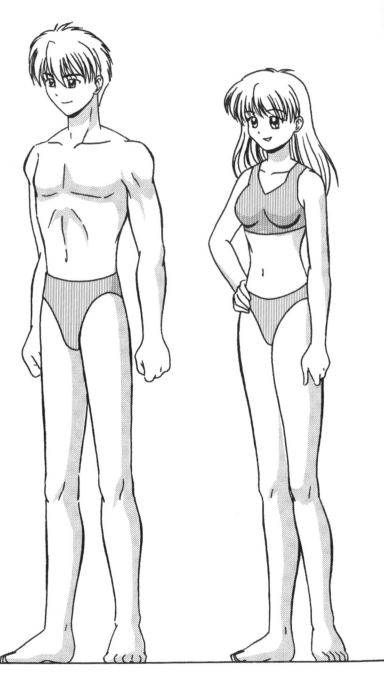

Rear View

Manga is filled with dramatic moments. Characters say pithy things, then turn and walk away. Sometimes they cry out for vengeance and chase after the bad guys. Sometimes they run after their boyfriends or girlfriends, or they snub someone and simply keep walking past without saying a word. So, it's a good idea to become familiar with the rear view. Things to note about this pose: The neck extends into the head, the spine begins between the shoulder blades, and there's space between the knees. Also, it's important to remember that the neck is not a separate bone but simply an extension of the spine.

Male

Female

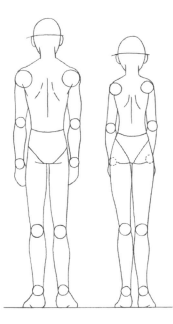

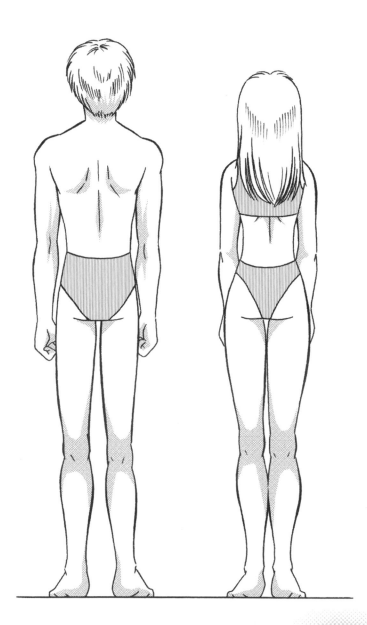

Arms

Arms generally have a bulge in the middle, even if it's subtle. There is usually a depression in the muscle's height, where a muscle originates and ends. Arms illustrate this idea of "ins and outs" well. Whether in the front, side, or rear view, the contours of the arm are evident. Take a look at the upper arm, forearm, and elbow contours here.

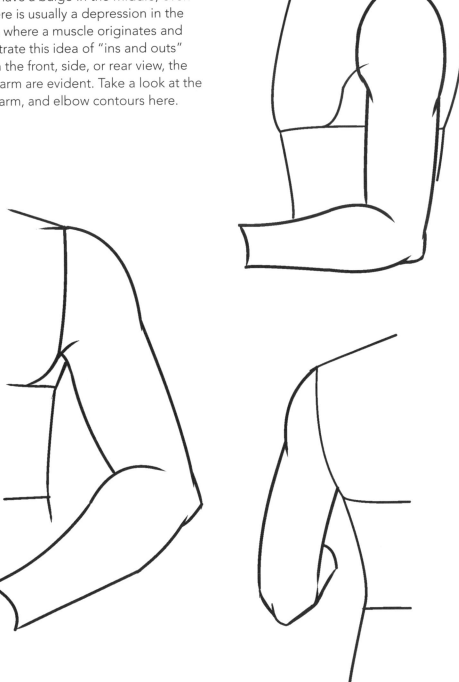

Side View

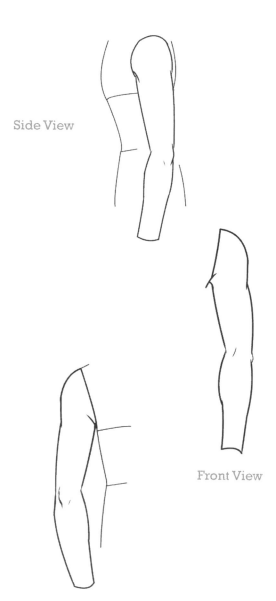

When the arm hangs down at the side of the body, the elbow falls just above the level of the waistline, at the bottom of the rib cage.

Front View

Rear View

Note the contours of the elbow, which protrudes in both the front and side views. A definition line in the rear view indicates this protrusion is there. You can also see that the natural "sweep" of the forearm is slightly forward when the arm hangs down in a relaxed manner.

Women's Arms

The female arm should be slender but should still have contours to indicate the ins and outs of the muscles.

Hands

Everyone has trouble drawing the hand. The principles I will explain make it easier. But this takes practice! So don't be hard on yourself if you don't get it right away. By studying the skeleton of the hand, you can gain an understanding of precisely how many joints there are per finger and where they appear. Note that each finger has three joints. The thumb also has three joints. (Many beginners erroneously assume the thumb has only two joints.) When beginning to sketch the hand, it's most effective to start by dividing the fingers into their various joints and also to indicate the knuckles along the crest of the hand mass. The finished hand is then the result of cleaning up the previous construction sketch and adding detail.

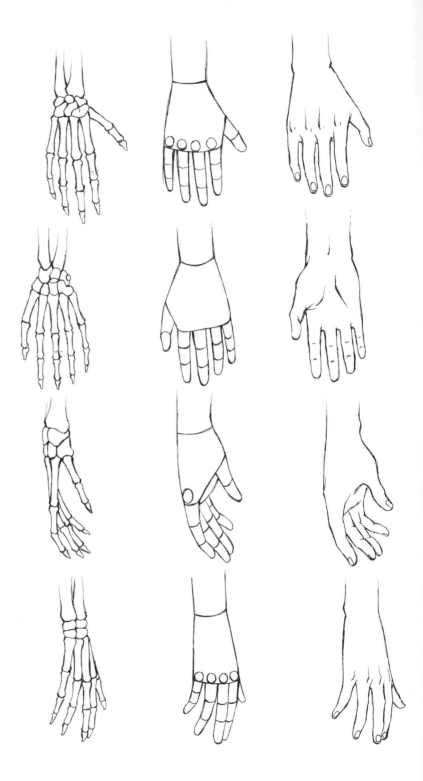

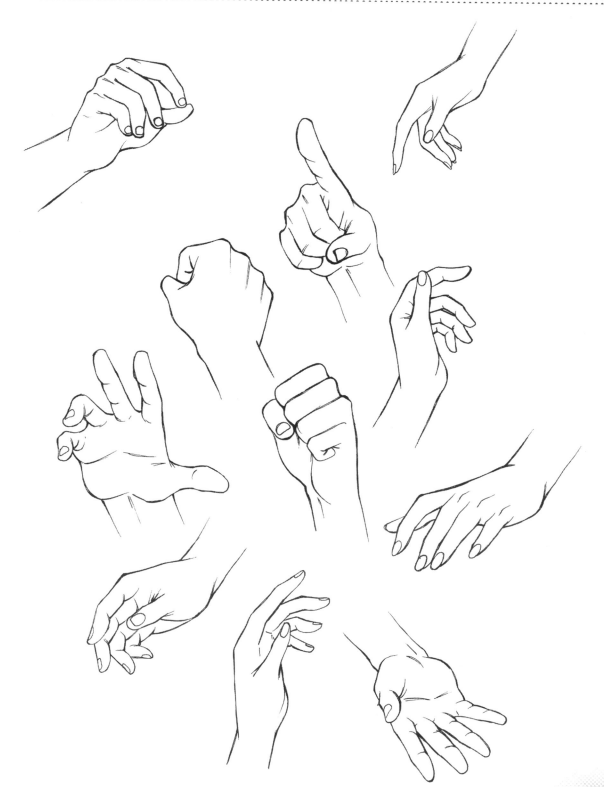

Legs

With just a little forethought, you can draw the leg in a very convincing manner. These are concepts that, once put into practice, quickly become second nature.

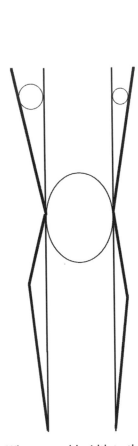

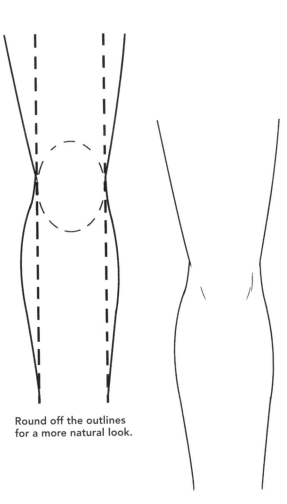

As a guide, start with a cylinder for the leg and an oval for the knee joint.

When you add width to the upper and lower legs, add more to the outer side and slightly less to the inner side. The muscles are not totally symmetrical on both sides of the bone.

Round off the outlines for a more natural look.

Erase the inner guidelines.

The Back of the Leg

To indicate the back of the knee, where there's a slight depression, use three definition lines. Keep it simple. Nothing fancy.

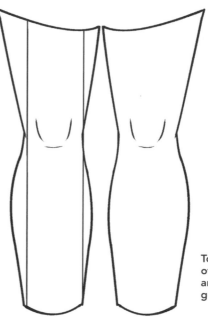

As with the front view, start with a column as your guide, and add width using straight lines that travel diagonally outward (more on the outer side than on the inner).

To finish, round off the outlines and remove the guidelines.

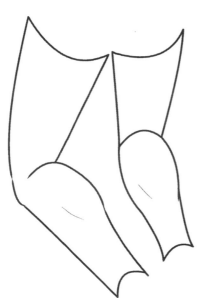

When a kneeling figure is seen from behind, the calf muscle overlaps a bit with the upper leg. Use an upward curving line to indicate this.

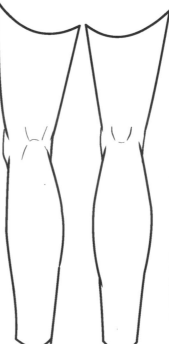

Even though this is the back of the knee, you can still indicate a little bit of the kneecap on this side of each leg.

Feet

By looking at the skeletal structure of the foot, you can see why the overall shape is formed the way that it is. The toes are all different lengths, just as the fingers are. And like the fingers, they all have three joints—except for the big toe, which only has two joints.

In the front view, the bridge of the foot should be truncated—i.e., foreshortened—due to the effects of seeing it in perspective. This gives the appearance that the bridge of the foot is rising high up into the calf.

In the ¾ rear view, you can clearly see that the heel has a separate, distinct bone (the calcaneus) that rises up into the Achilles-tendon area.

In the side view, the heel protrudes slightly past the calf. This is important, because beginners tend to draw the heel flush with the calf, which makes the foot look awkward.

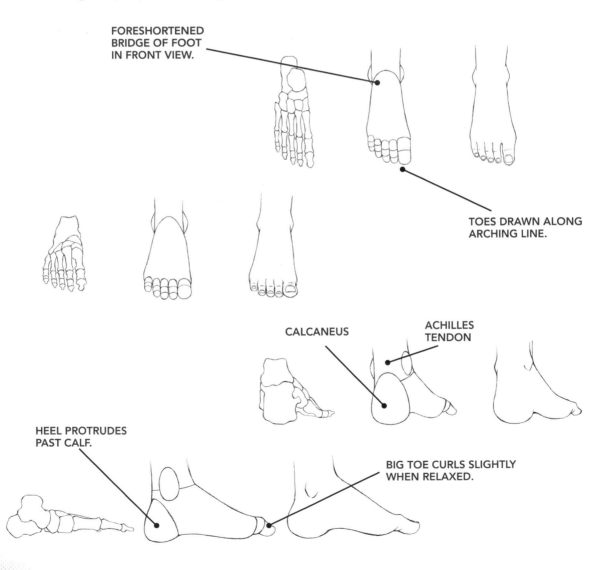

FORESHORTENED BRIDGE OF FOOT IN FRONT VIEW.

TOES DRAWN ALONG ARCHING LINE.

CALCANEUS

ACHILLES TENDON

HEEL PROTRUDES PAST CALF.

BIG TOE CURLS SLIGHTLY WHEN RELAXED.

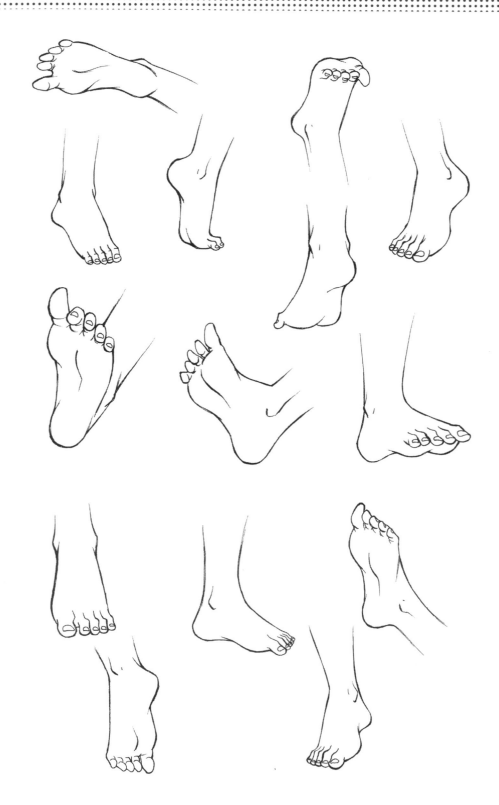

Height

We often think of height as something that is relative. In other words, a character only looks tall or short when standing alongside an object whose size the reader is already familiar with.

But this isn't the way it really works. Characters look tall, medium, or short in stature based on their own proportions, regardless of whether there is anything else to compare them to. Artists create this effect by using the character's own head as the unit of measurement to determine overall height. Generally, a cute character is 4 to 6 "heads tall." An average character is 6 to 7 heads tall. A tall character can be 8 to 9 heads tall. And superstylish characters such as bishounen and bishoujo, as well as gothic characters, can be even taller. On the other end of the spectrum, supercute chibis can be as few as three or even two heads tall!

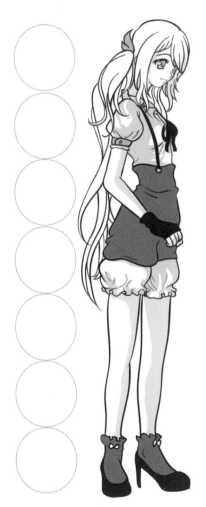

7 Heads Tall (Average)

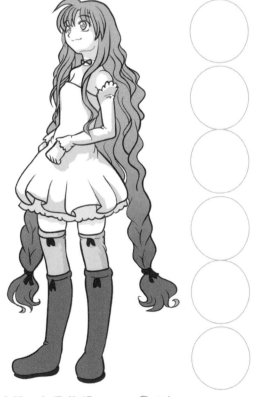

6 Heads Tall (Average Cute)

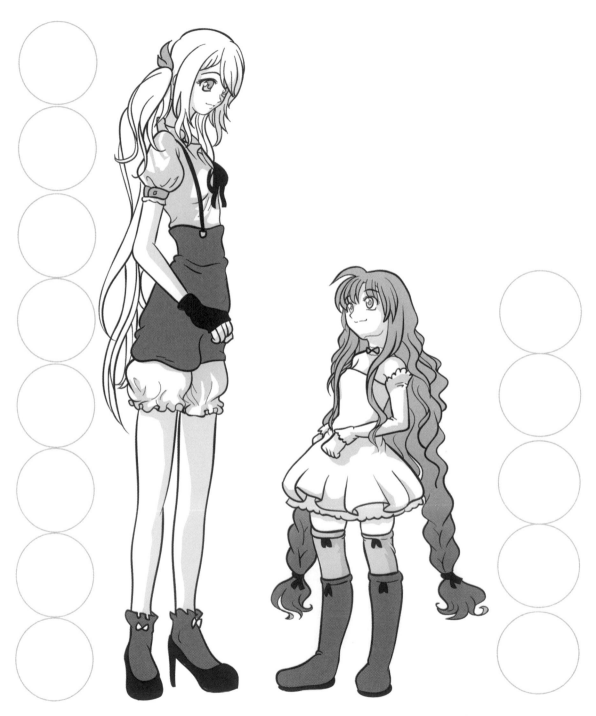

8 Heads Tall (Supertall) 5 Heads Tall (Petite)

Age/Height Comparison

Manga has more variations and subdivisions among its young characters than any other genre of comics, with tweens (about ten to thirteen years old), young teens, middle teens, and older teens all featured. It's important to match the height, angularity, and muscle development of a character with his or her age.

A manga boy character starts out life with a soft, round build. In the teen years, he becomes skinny and lanky. As an adult, he begins to fill out and gain muscles. Note, too, that the younger the character, the larger the eyes.

As little children, manga girls have cute, pudgy, pear-shaped bodies with little tummies. Then they sort of "string-bean-out" between the ages of eight and eleven. From twelve to fourteen, they begin to assume a feminine shape. In the manga genre, they maintain that look throughout the high school years.

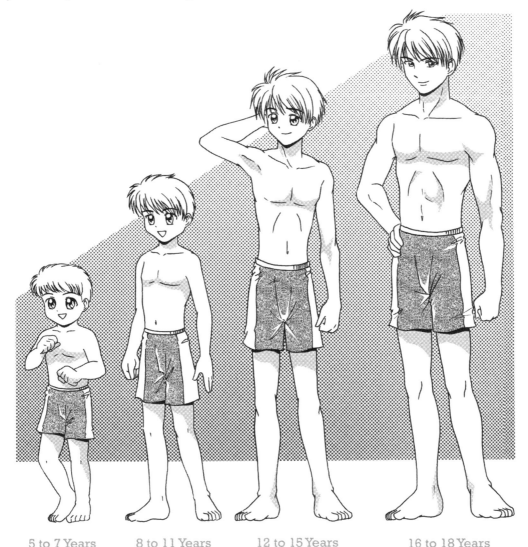

5 to 7 Years 8 to 11 Years 12 to 15 Years 16 to 18 Years

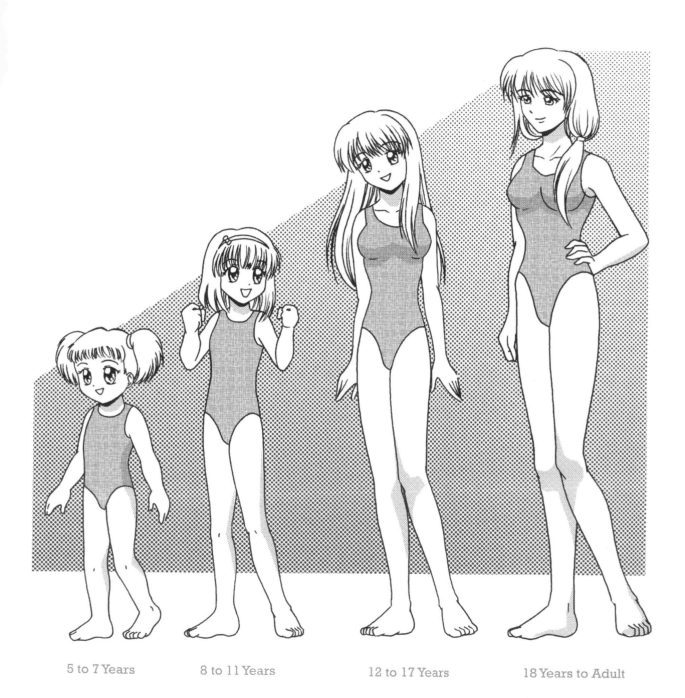

5 to 7 Years 8 to 11 Years 12 to 17 Years 18 Years to Adult

PART TWO
Let's Draw It

Pretty Teen Girl

Stiff poses just don't cut it in manga. But here's the secret: a character doesn't have to be throwing a punch to convey a sense of movement. By simply curving the line of the spine slightly, the pose takes on an appealing look. Also note the hip that pushes out and the knee that bends in.

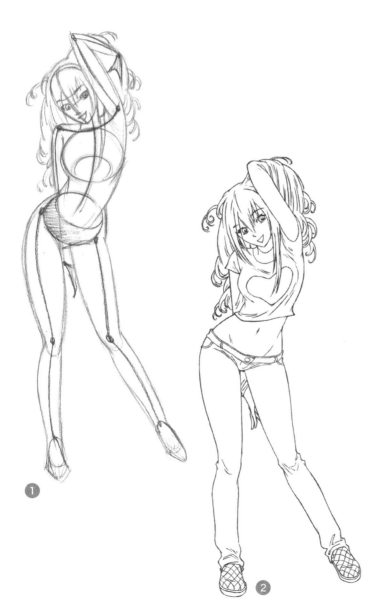

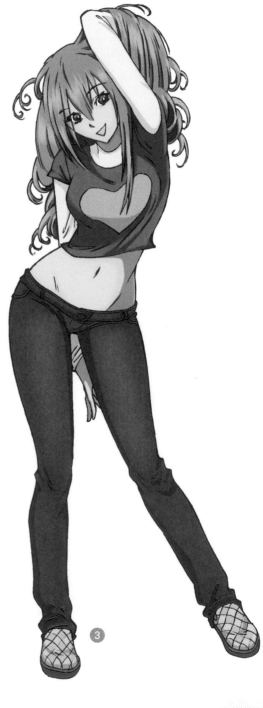

Handsome Teen Boy

This casual, good-looking character is very popular with readers of high school manga adventures. He's a "teen crush" who wears oversized, baggy clothes. This guy's an American charmer. He has been known to cause long-standing friendships to dissolve into catfights. His slightly disinterested look makes him seem unattainable, and to high school girls, that makes him utterly irresistible. Go figure.

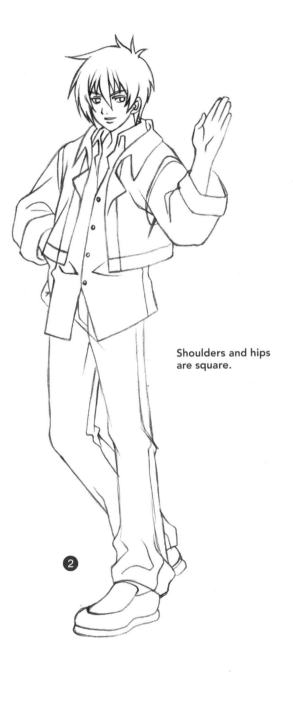

Shoulders and hips are square.

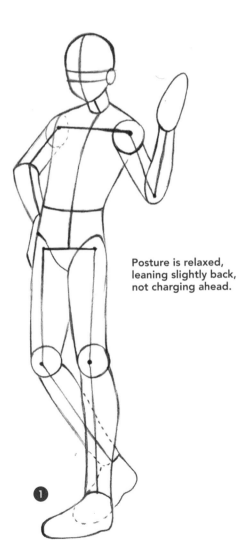

Posture is relaxed, leaning slightly back, not charging ahead.

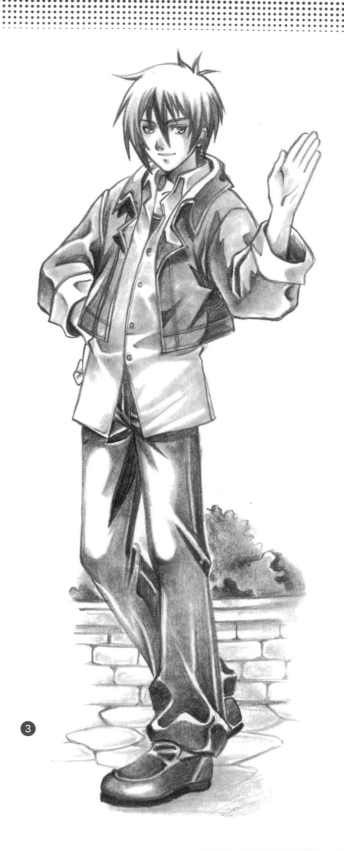

3

Schoolgirl Cat-Girl

Cat-girls are reader favorites and appear in all genres of manga. Although they live among, and interact with, humans, they retain a lot of their cat personality traits, such as curiosity, mischievousness, and impulsiveness. Some of them have stripes, like tabby cats. Don't try to explain their appeal to your parents. It's hopeless!

Schoolgirls are also manga favorites, so combining the schoolgirl with a cat-girl results in a character that really packs a punch. The schoolgirl cat-girl fits in like any other student and has lots of human friends. But the cat-girls who appear most like humans are the ones who work best in the high school environment. If they are very catlike, they'll be too distracted by quick movements to pay attention in class.

Note that these ears seem to grow right out of the head. Some artists, however, use a headband with the cat ears attached to them instead of this organic look. Either way is a popular convention. The interior of the cat ear is almost always lighter in color than the exterior.

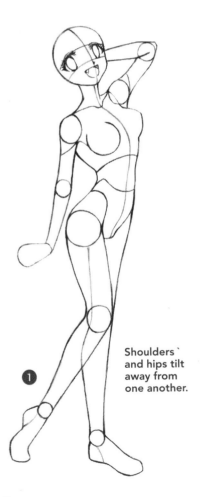

1 Shoulders and hips tilt away from one another.

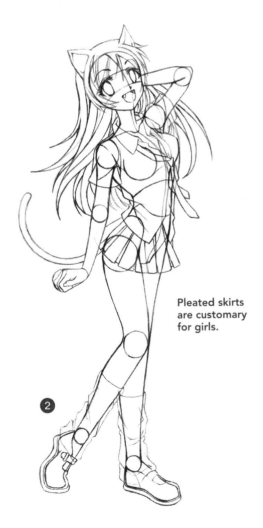

2 Pleated skirts are customary for girls.

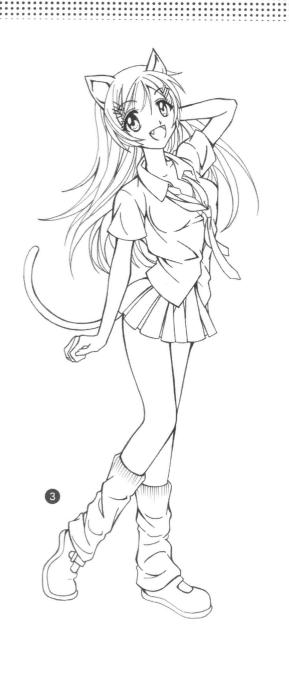

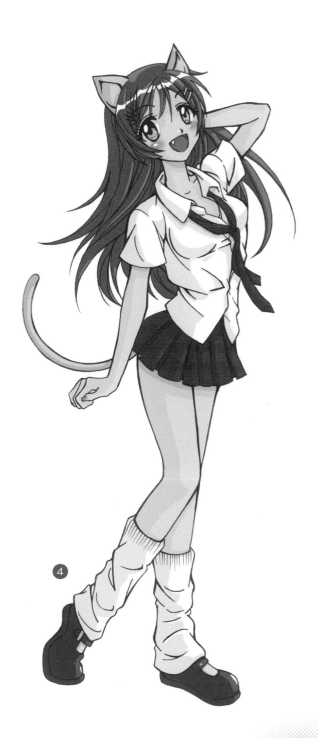

Classic Teen Hero

You see this superpopular character everywhere. Readers love him. He's intense and never gives up, no matter how much danger stands in his way. Oh sure, he takes his share of hits, but he's resilient and keeps coming back. As you flesh out the figure, indicate the effects of perspective, enlarging those parts of the body that come toward you and reducing those that recede.

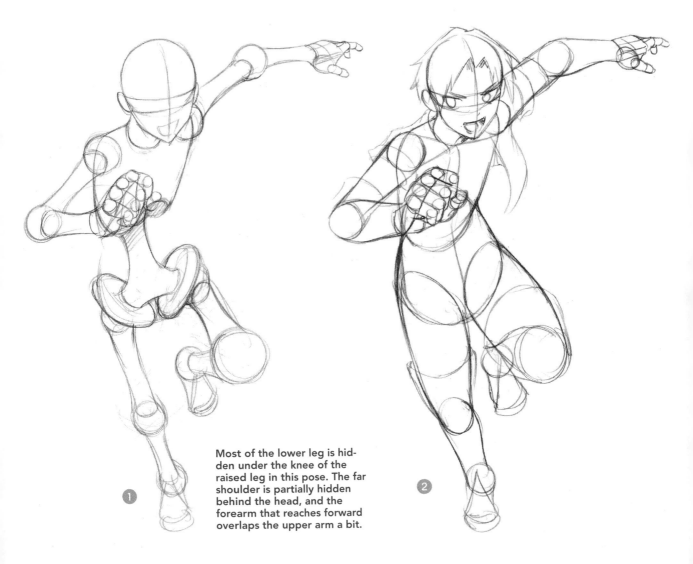

Most of the lower leg is hidden under the knee of the raised leg in this pose. The far shoulder is partially hidden behind the head, and the forearm that reaches forward overlaps the upper arm a bit.

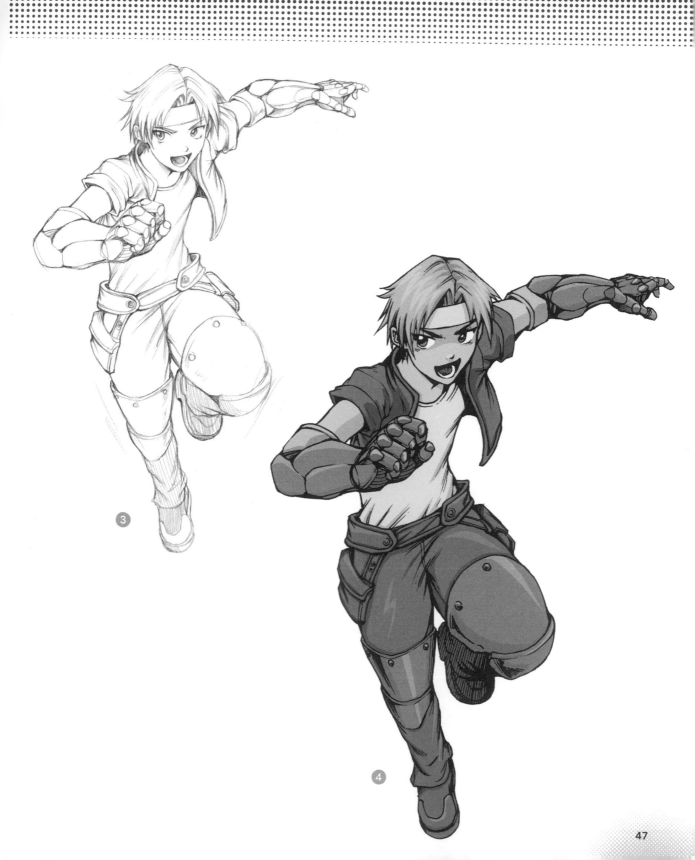

Sushi Girl

This top chef is donning a typical Japanese robe. It's loose and comfortable. She also wears a headband and sash, and if her feet were showing, you'd see that she wears sandals with socks.

Apprentices like our young sushi chef are proud of their work. She can't wait to show this well-prepared meal to the head chef! Of course, the cat will make sure that, the moment she turns her back, the California roll goes bye-bye, leaving her nothing to show for her hard work. Except for a burping cat.

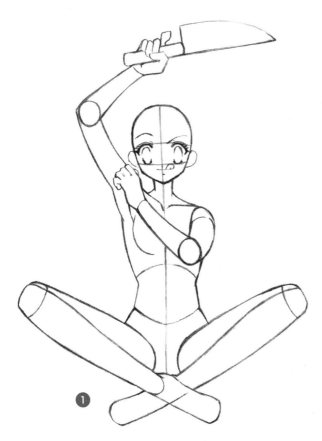

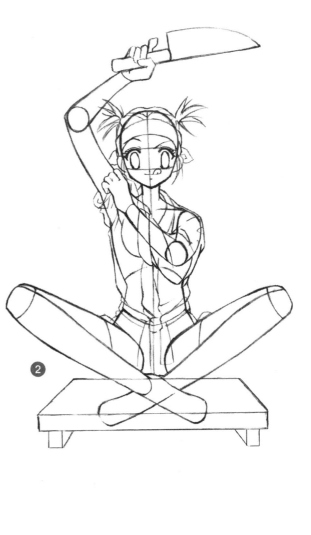

Shoulders tilt on an angle. Both knees and legs are perfectly symmetrical.

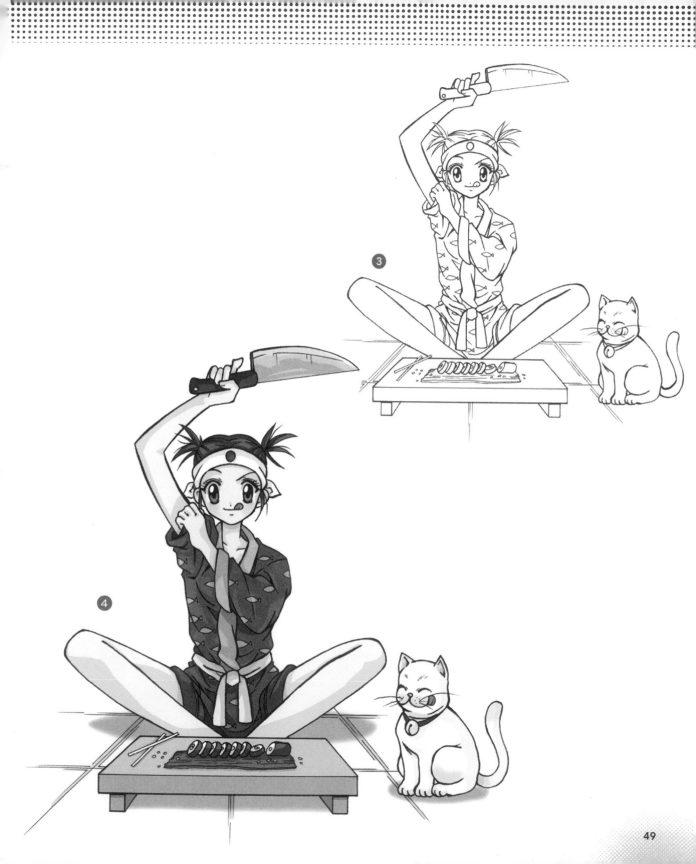

Kung Fu Grand Master

This guy isn't spending his nights playing bingo at the local community center. In fact, if you want to learn the most closely guarded secrets of martial arts, you come to him, but he will impart this knowledge to only his most trusted students.

The slippers and high collar are part of traditional kung fu outfits. The long, thin beard and braid give him a mysterious, yet wise, appearance. Unlike a student's clothes—including those of the master disciples—the grand master's uniform is flamboyant, with a splashy pattern. This puts him in a class above everyone else, which he has earned, and brings him awe and respect.

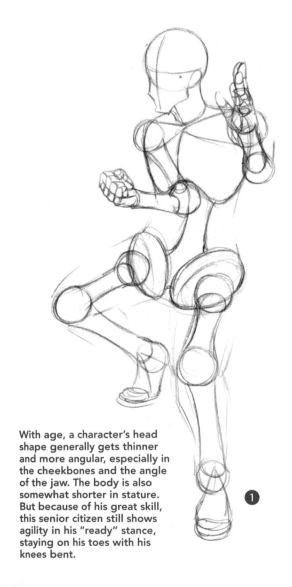

With age, a character's head shape generally gets thinner and more angular, especially in the cheekbones and the angle of the jaw. The body is also somewhat shorter in stature. But because of his great skill, this senior citizen still shows agility in his "ready" stance, staying on his toes with his knees bent. **①**

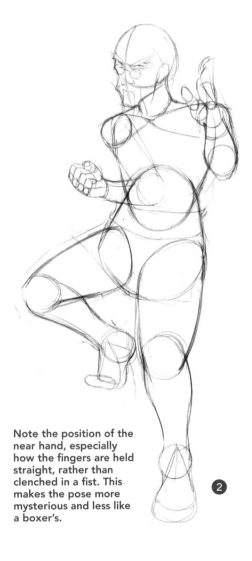

Note the position of the near hand, especially how the fingers are held straight, rather than clenched in a fist. This makes the pose more mysterious and less like a boxer's. **②**

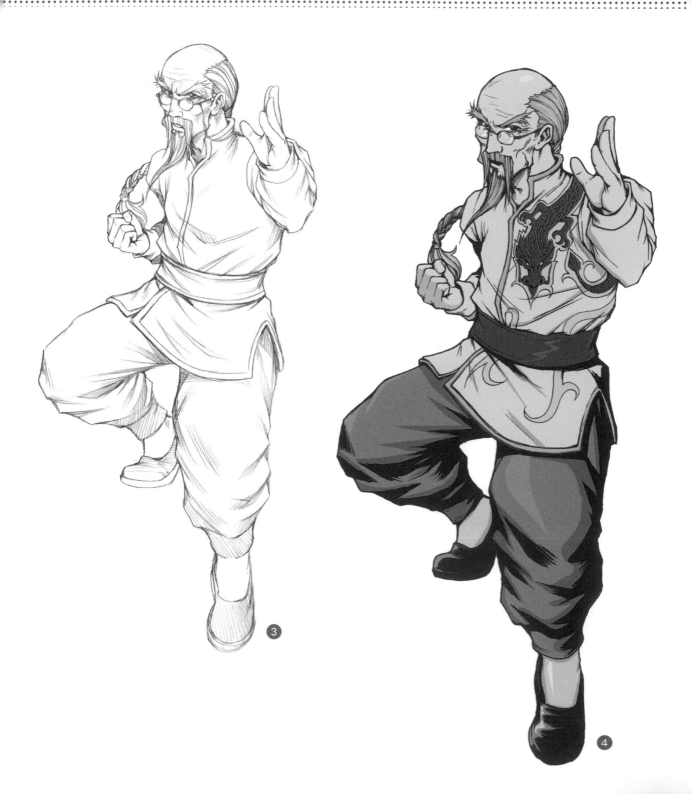

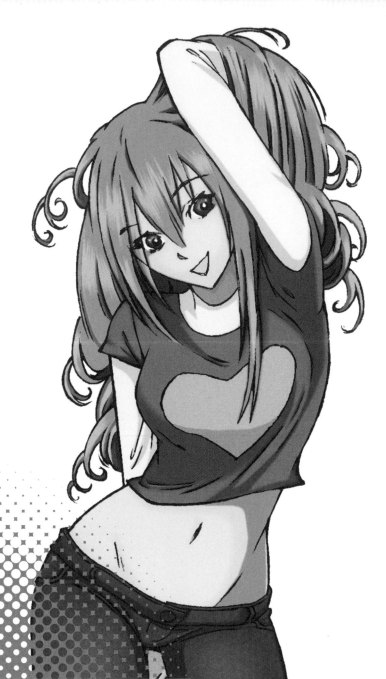

PART THREE
Let's Practice It

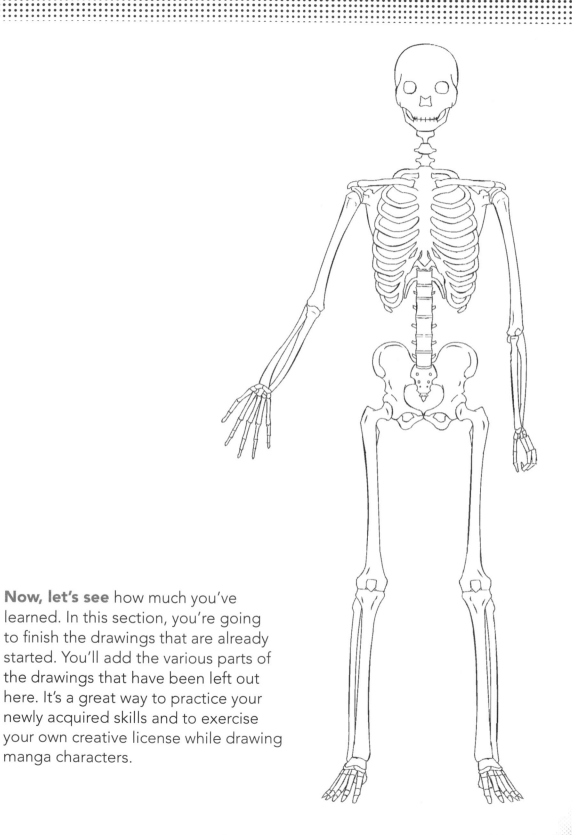

Now, let's see how much you've learned. In this section, you're going to finish the drawings that are already started. You'll add the various parts of the drawings that have been left out here. It's a great way to practice your newly acquired skills and to exercise your own creative license while drawing manga characters.

Draw the eyes on these two characters.

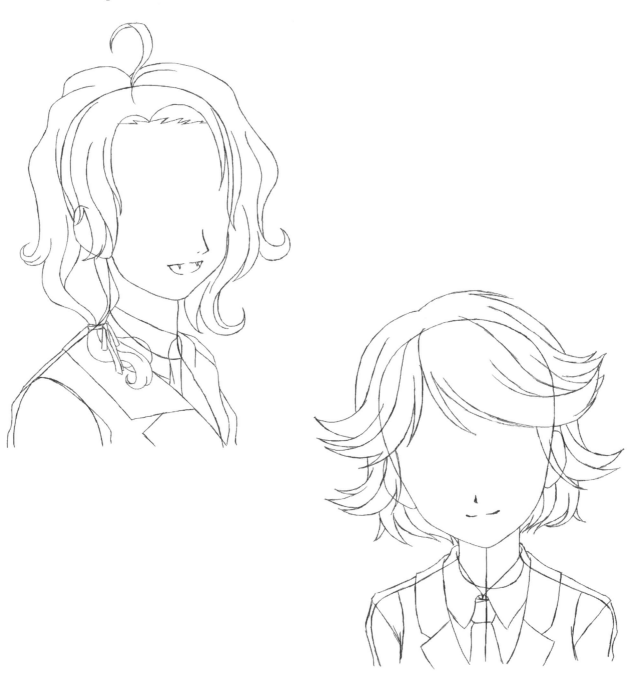

Finish the drawing of this girl in profile by developing her facial features and adding hair.

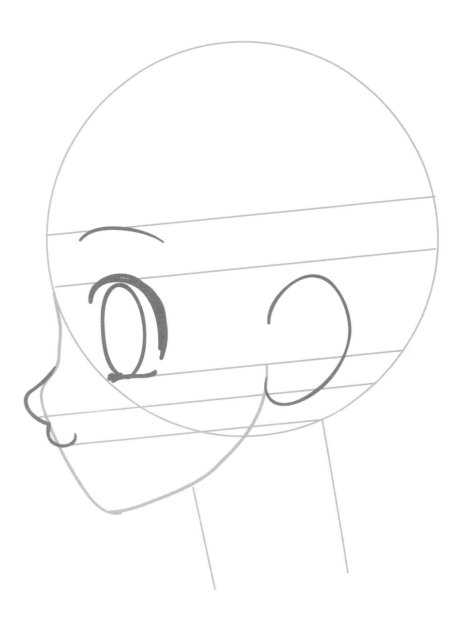

Try doing the same thing on a boy character—finish the face and add details to his facial features. He'll also need some hair.

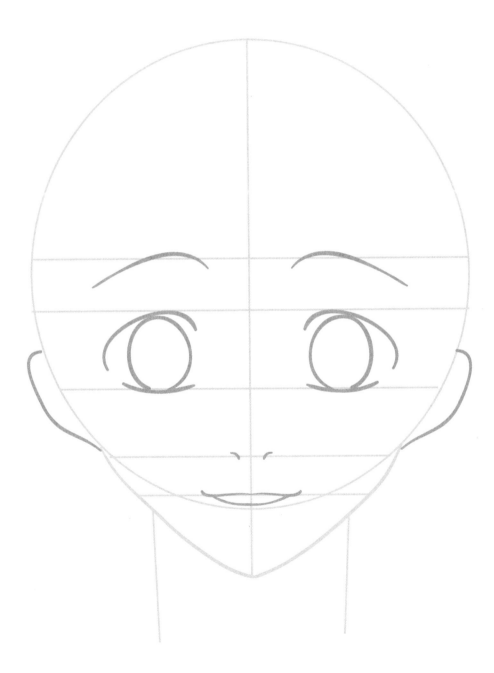

This diagram of the skeleton is missing some bones. Can you add them in, making sure they fit in with the rest of the skeleton?

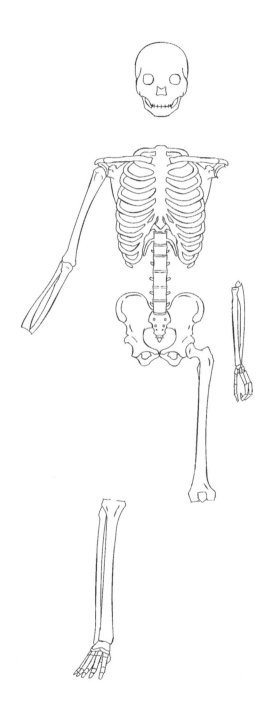

This guy is missing some muscles. Can you add them in? Flip to page 18 if you need help.

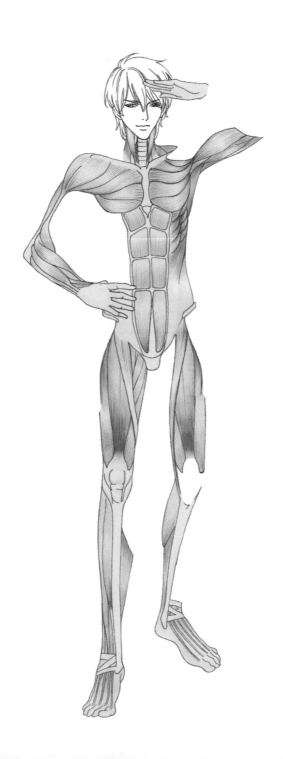

Draw the arms on this boy character.

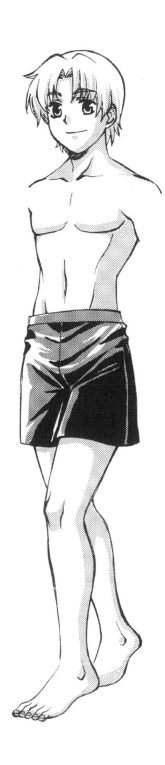

Add the arms to this girl.

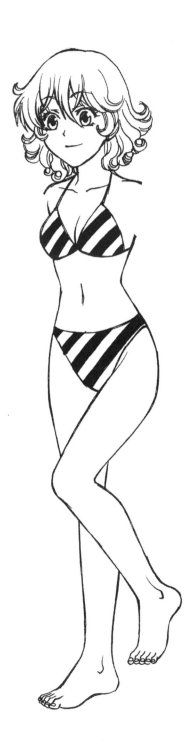

**Draw the legs on this
girl character.**

Add the legs to this boy.

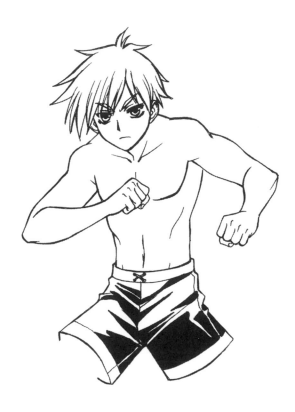

Finish the drawing by giving this girl a body.

Finish the drawing by giving this boy a body.

Also available in *Christopher Hart's Draw Manga Now!* series